DEGAS
BACKSTAGE

First published in Great Britain in 1996 by
Thames and Hudson Ltd, London

© 1996 by Éditions Assouline, Paris, 1996

British Library Cataloguing-in-Publication Data

A catalogue record for this book is available from the British Library

ISBN 0-500-32731-X

Printed and bound in Italy

DEGAS
BACKSTAGE

TEXT BY RICHARD KENDALL

THAMES AND HUDSON

the wings of a theatre are where fact and fiction meet, an in-between world of dissolving identities and fragile glamour, of chaos, tedium and bizarre contradiction. Here dancers do not dance, pastel-coloured tutus and butterfly wings become absurd appendages on weary bodies, and the mechanics of illusion – the ropes and pulleys, the banks of lights and painted panoramas – reveal themselves in all their banality. Behind the waiting performers, a world of grim practicality prevails, in a labyrinth of ill-lit corridors and stale dressing rooms, in cavernous rehearsal halls where weeks and months of weary exercise have prepared them for the production of the moment. But glimpsed through the scenery, past the canvas flats and cardboard foliage, all is artifice and enchantment. On stage, the ballerinas float weightlessly in a blaze of light, buoyed up on waves of music and transformed by colour, movement and purposefulness. Now roles are spelt out to the last pirouette and the smallest

detail of costume, events are unfolded in mysterious, rhythmic patterns, and disbelief is willingly and energetically suspended. Or is the opposite the case? Does the tinselled spectacle become the reality, willed into substantial being by a thousand pairs of eyes, each of them oblivious and uncomprehending of the disorder that lies behind the scenes? What could be more persuasive than brilliantly lit human figures in vigorous action, captivating effects of moonlight and the roll of theatrical thunder? And of what interest is the insubstantial world off-stage to an audience that has surrendered its rationality? For them the wings hardly exist, and the shadowy population of scene-changers and technicians, prompters and directors, even the endlessly waiting performers who have yet to make an entrance, are literally and metaphorically invisible.

Yet it was this shifting, transitional universe and these visual conundrums that occupied Edgar Degas for more than forty years of his working life, resulting in least a thousand drawings, pastels, prints and oil paintings – to say nothing of photographs, poems and wax sculptures – of the ballet. The glamour of the performance itself occupied him relatively little. Though there are a number of magnificent representations of the ballet in progress, some of which can be related to known productions of his day, these pictures make up a small minority of Degas's output of dance scenes. It was the paradoxes of the dancer's world that he addressed: the unbeautiful routines of the practice room and the drabness of corridors; the moment of transformation as performers left or entered the stage; and the inertia of waiting

and the squalid amorousness of backstage life. As his ballet-loving friend Ludovic Halévy noted: 'Degas is always on the look-out for the unexpected.'

degas's first ballet pictures were made towards the end of the 1860s, when the artist was in his mid-thirties and still virtually unknown in the Paris art world. Pictures such as his portrait of Mlle Eugénie Fiocre in the ballet *La Source* and *The Orchestra of the Opéra* show him tackling the public face of the dance, taking his place among the audience and responding to a dramatically eventful or visually compelling moment in the performance. A precocious canvas from the early 1870s like *Dance Class at the Opéra*, by contrast, marks out the backstage territory that he was soon to make his own. Such pictures were also part of Degas's wider project at this period, to depict his urban milieu in all its diversity and in the vigour of its self-conscious modernity. Scenes of horseracing and holiday excursions to the beach, studies of businessmen in their offices and of bourgeois living rooms all announced Degas's conversion to the 'school of realists', as he called it, and his determination to find appropriate means of representing his mobile, abrasive surroundings. As in *Dance Class at the Opéra*, figures in these pictures tend to be informally grouped, narratives are oblique or non-existent, and the sheer ordinariness of city life often becomes the effective subject of the painting. In nineteenth-century Paris the ballet was a highly popular form of entertainment, conspicuously patronized by the rich and fashionable but avidly followed by the city's burgeoning middle classes. With its celebrated stars and

scandals, the dance enjoyed something of the role of the cinema in our own culture and as such claimed a place in Degas's metropolitan enterprise, alongside the café-concerts, cabarets and circuses that engaged both him and a number of his painter-contemporaries.

From the beginning, Degas's backstage scenes were as artificial as the world they represented. Each of the ballerinas was separately posed in the artist's studio, often by a model who was an off-duty dancer, then drawn as a discrete study for future reference. Using these drawings, Degas would then devise his ballet compositions like an elaborate patchwork, transferring each figure to its appropriate position, enlarging some and reducing others to mere background spectators. The room in which they are depicted or a setting in the wings would then be reconstructed from memory or freely improvised, and the entire scene gradually, but entirely synthetically, coaxed into being. Working with his oil paints or pastels, the artist could invent the colours of the dancers' dresses and manipulate the fall of light, modify the shape of the practice room or introduce a piano, a mirror, a dancing master or a pet terrier, all according to his whim and his ambitions for the picture.

this interweaving of observation and artifice makes up the essential fabric of Degas's dance repertoire. In his studio, hundreds of drawings, notebook studies and rapid sketches, like *Seated Dancer in Profile* and *Standing Dancer Seen from Behind*, allowed him to improvise freely on a chosen theme or re-use a figure from one successful painting in another, sometimes radically different, composition. The finest of these

studies show him scrutinizing the dancers at work and at their leisure, in moments of discomfort, playfulness and boredom. Frequently, Degas chose a revealing gesture – an elbow crooked over a back, a hand adjusting an earring, a foot artfully positioned – to locate his image in the actuality of the dance. Though re-created in the studio, we know that Degas encountered these details at first hand, both in visits to the ballet and in privileged access to the world behind the scenes. Celebrated for the accuracy of his memory, Degas occasionally noted down in his pocket-book the sights and sensations of the theatre. Such fleeting glimpses offered the most acute challenge to Degas's skills and technical invention. Translated into paint and pastel, they became the truncated figures, the blurred and summary figures and the fractured light effects of his Impressionist dance subjects, instantly recognizable today and much imitated in his own age. Degas worked hard at this new pictorial language, experimenting with an extraordinary range of techniques and hazardous, sometimes shocking approaches to his chosen theme. In his notebook, he recorded some of his plans for future projects:

> a severely truncated dancer – do some arms or legs, or some backs – draw the shoes, the hands of a hairdresser, the built-up hairstyle, bare feet in the act of dancing etc. etc ... After having done portraits seen from above, I will do some seen from below – sitting very close to a woman and looking up at her ...

Many of the ballet pictures that resulted seem to capture this sense of improvisation and visual excitement, not just in their subjects – 'seen from below ... seen from above' – but in their unexpected conjunctions of materials. Often they were pasted

8

together from several sheets of paper, Degas extending his composition or changing his field of view as the work progressed. Experiments also took place with unorthodox paints and colours, among them the matt effects of gouache and distemper that so closely resemble scene-painters' materials. The same qualities even invaded the papers and canvases he chose, ranging from brilliantly tinted green and blue card to the fine silk used for a number of painted fans and to coarse canvas that again recalled a theatrical material, this time scrim or hessian. As he became more reckless, Degas would combine several media on the same long-suffering surface. Throughout the 1870s, the artist showed the same technical adventurousness in his approach to print-making, a craft in which he had few rivals in practical originality. His trials were crowned by the invention of a print process that was effectively his own invention: the monotype.

around 1876 or 1877, Degas produced a series of pictures of backstage life that are amongst the most original works of his career. These are the Famille Cardinal monotypes, a set of thirty or so black-and-white prints that follow the fortunes of two young sisters, Pauline and Virginie Cardinal, as they make their way in the world of the dance. The monotype medium involved making a drawing in black ink on a shiny copper plate, then laying a sheet of paper over it and applying pressure to produce a single print with a highly appropriate resemblance to a photograph or a book illustration. Degas's pictures were evidently planned to accompany a group of short stories written by Ludovic Halévy. For reasons that remain unclear, Degas's monotypes were not used to illustrate

9

Halévy's text when it was published, though their episodic and suggestive character capture with remarkable vividness the fragmentary life of the wings that the two men knew so well.

The Cardinal Sisters Talking to their Admirers employs the simplest graphic means to express the fragility of the two Cardinal girls amid the attentions of their bulky male admirers, while around them the ill-defined space hints at insecurity and transience. As so often in these prints, blocks of tone or a perfectly judged flick of the brush will isolate a feature or establish mood, hinting at the claustrophobic nature of theatre life or the speed of social exchange. In *Intimité*, a tilted dressing room and mirror, the rakish angle of the chair and a shadowy male presence, combine to evoke an almost farcical sense of dishevelment. In this print, the dancer is willingly the centre of attention as she hastily completes her make-up and prepares to step from the wings into the glare of the stage lights. By contrast, in *Ludovic Halévy Finds Mme Cardinal in the Dressing Room*, we are left with the squalid, disorganized actuality of rooms heaped with costumes and accessories, where Mme Cardinal waits for her charges and a top-hatted visitor to the Opéra, mischievously rendered by Degas in the guise of Halévy himself, keeps her company.

the frank sexuality of many of the Famille Cardinal prints – with their scenes of rampant flirtation and hot pursuit in the offstage labyrinth – has not entirely lost its power to shock. In Halévy's published stories, this licentiousness is even more apparent, though so much taken for granted in the theatrical world he describes that it hardly causes comment.

From the beginning, it is made clear that Pauline and Virginie have barely reached their teens, yet both are either co-habiting with an older man – in Virginie's case, an Italian *marquis* – or are besieged by admirers 'who hardly leave the house', in the garrulous Mme Cardinal's words. In such circumstances, the girls' mother is both the solemn guardian of her daughters' welfare and the agent of their downfall. In both Halévy's text and Degas's imagery, the figure of Mme Cardinal, 'an old plaid shawl on her shoulders and vast silver spectacles on her nose', is implicitly involved in advancing the careers of her charges, as much by advantageous liaisons as by the girls' professional excellence. She interests herself in every aspect of backstage intrigue and the life of the Opéra, noting with satisfaction that the ballet director himself had recently seen Pauline dance and 'taken her by the chin', and insisting that 'he doesn't take everyone by the chin, the director'.

Modest though they are in scale and finish, the Famille Cardinal monotypes remind us forcefully of the social realities of the dance in Degas's day. For working-class Parisian girls, the dance offered a life of hard drudgery and long hours, of pitifully low pay with the prospect of advancement to the *corps de ballet* or even, more remotely, to stardom. Far from being the light-limbed athletes we associate with the dance in our own age, members of the chorus had often earned their place through doggedness rather than skill, augmented by endless manœuvring in the highly politicized theatrical world. Appearances on the stage allowed them to advertise their charms, an opportunity brazenly exploited by the dancers themselves and frankly reported by some of the newspaper critics, who would devote as much space to a new beauty as to the virtues of a performance. Though daughters of 'respectable' homes might

also pursue a career in the ballet – evident in such works by Degas as the pastel *The Mante Family* – it was widely assumed that many dancers were underpaid, exploitable and sexually available.

If the sombre, duplicitous figure of Mme Cardinal and her sister-chaperones is a standard fixture in Degas's rehearsal scenes – appearing again, for example, in *Dancers at their Toilette (The Dance Examination)*, *The Dance Class* of 1881 and *The Dance Foyer* – the lurking male figures of the dancers' admirers are even more ubiquitous. Typically seen as dark, vertical presences of a rather sinister kind, and ironically epitomized in Degas's two colleagues Ludovic Halévy and Albert Cavé in *Portrait of Friends in the Wings*, these predatory creatures hover in the shadows beside the stage, stalk the corridors and cluster in the dance foyer before and after performances. Frequently such figures can be found in Degas's depiction of the wings or even glimpsed just off-stage, as in the top-hatted spectator of *Entrance of the Masked Dancers*. By turns gross and comical, they epitomize the conjunction of formality and licence, of masculine control and female subservience, that animates much of Degas's dance vocabulary. These male subscribers to the Opéra, or *abonnés*, were usually wealthy or distinguished members of the establishment, with free access to backstage areas of the theatre where they would meet each other and the dancers they currently favoured, or prepare for the remainder of the evening's entertainment. Though not affluent himself, Degas certainly joined their company on many occasions, and it was from his personal experience, or at least first-hand observation, that his monotypes and pastels of such subjects undoubtedly emerged.

the uncertainty of the ballet dancer's life and the simple drudgery of her routine became the subject of many of Degas's finest works of art at mid-career. *Waiting* deals with lassitude and anticipation, as the young apprentice sits beside her guardian, preparing her angular frame for audition, for a dance examination or for the interview that may launch her career. Here again, the mundane – emphasized by the bare floorboards, the chaperone's dismal outfit and her near-comical umbrella – meets the fantastic, graphically symbolized by the dancer's fluffy white costume and the touches of colour in her ribbons. Other studies from these years show the life that awaits the young hopeful: *Dancers Climbing the Stairs* follows some of the corps de ballet as they rush to rehearsal or submit to instruction; *The Dance Class* of 1881 juxtaposes the vigorous exertions of the daily exercise with the idleness of those waiting their turn; and *The Dance Foyer* confronts the endless attention to costumes, ballet shoes and coiffure that preceded each appearance on stage or at the dance examination. This is a world of work and discipline, one that curiously echoes the dedication of the visual artist and clearly struck a sympathetic chord with Degas himself – a man described as 'labour incarnate' by one of his later admirers, whose life was 'as ordered and arranged as a sheet of music'.

between 1874 and 1886, Degas emerged from relative obscurity to become one of the most prominent members of the Impressionist group, exhibiting his pictures in most of their co-operative displays and busily involving himself in their organization, publicity and detailed

installation. Many of his distinctive subjects were launched at these exhibitions, but it was the ballet that was soon identified as his personal artistic trademark. Critics wrote admiringly that 'his studies of *danseuses* assert a rare and original talent', suggesting that such pictures joined his representations of bathers, café scenes and cabarets as 'just so many little masterpieces of clever and accurate satire'. Some commentators found his drawing too abrasive for their taste, but one claimed that 'the movements of his little figures are piquant and accurate, and his colour is brilliant'. Reflecting on the superb pastel *Dancers at their Toilette (The Dance Examination)*, the novelist Joris-Karl Huysmans wrote:

> What truth! What life! See how realistic these figures are, how accurately the light bathes the scene. Look at the expressions on these faces, the boredom of painful mechanical effort, the scrutiny of the mother whose desires are whetted whenever the body of her daughter begins its drudgery, the indifference of the friends to the familiar weariness. All these things are noted with analytical insight at once subtle and cruel.

Identified as a specialist in the dance, Degas was almost routinely admired for his fine draughtsmanship, his responsiveness to the modern spectacle and his sharp, relentless observation in scenes of the wings and the rehearsal room. Few of his admirers were prepared, however, for the *Little Fourteen-Year-Old Dancer*, a two-thirds-life-size wax sculpture dressed in a fabric bodice and gauze tutu, which seemed to spell out the adolescent precocity of the dance and prompted a critical storm when it was first shown in the Impressionist exhibition of 1881.

Why, in so many of his pastels, paintings and works of sculpture, did Degas choose the subject of the dance? No artist before him had concentrated so intensely on the theme, though he was well aware of a number of precedents and distinguished precursors. For example, the eighteenth-century pastellist, Jean-Baptiste Perroneau, an artist represented on the walls of the family home when Degas was growing up, had made portraits of the ballerinas of his own epoch and had been famous for 'frequenting the wings of the Opéra'. Nearer to Degas in time, the mid-nineteenth-century painter and caricaturist Honoré Daumier had often tackled backstage subjects, lampooning the pretensions of stars and management alike and establishing an audacious pictorial vocabulary for his successors. Daumier's compositions were openly acknowledged in certain works by Edouard Manet, such as his 1862 oil painting *Lola de Valence*, where a magnificently costumed dancer poses self-consciously against a scenery flat, allowing us the briefest of glimpses of the stage behind. Though pre-dating Degas's first studies of the subject by several years, such pictures remind us how rarely he presented his *dramatis personae* on their own terms, preferring to catch them off their guard and in their less elegant moments.

According to an acquaintance of his later life, the art dealer Ambroise Vollard, Degas once explained: 'They call me the painter of dancing girls. It has never occurred to them that my chief interest in dancers lies in rendering movement and painting pretty clothes.' As always, we must be cautious of accepting the artist's reported words at face value and of applying a statement from Degas's old age to his earlier career. Though 'rendering movement' and painting the colours and textures of the dancers' costumes was always an element in

Degas's project, there can be no doubting his serious commitment to the ballet itself in the Impressionist years, nor to his involvement in documenting the dancers' paradoxical world. Along with such major novelists as Emile Zola, Jules and Edmond de Goncourt and Joris-Karl Huysmans, all of whom Degas met or knew at some time, as well as writer-acquaintances like Ludovic Halévy, Degas put a significant part of his energy at this period into the itemizing and cataloguing of the contemporary world. Turning from the historical and imaginary themes that had occupied their forebears, these artists addressed the tensions of the city and the life of the suburbs, finding drama in railways, insalubrious bars and backstreet sweatshops.

but as Degas's remark makes clear, his role as chronicler of modern life was only one of the parts he played, and one that by no means defined every phase of his career. For Degas, the ballet was first and foremost an engagement with the human body, one of the greatest challenges for any artist and the principal concern of the masters he so persistently revered. Whether in repose or in wild, revealing movement, the ballet dancer allowed Degas to address the body in all its extremes of dynamism, offering an utterly modern equivalent to the goddesses and heroines, the nymphs and dryads of the past. Studying a dancer in his studio, Degas could draw her contrived stance as Raphael would once have drawn a model posed as an angel or as Poussin had conjured up his women of antiquity.

Celebrated as a draughtsman and courted as the natural successor to Poussin and Ingres, Degas allowed his scenes of the

dance to take on an expansiveness that revealed a new confidence in his means. Though his canvases were rarely large, pictures such as *The Dance Class* of 1881 are monumental in their disposition of form and space, and masterly as expressions of organized movement. Here an implicit diagonal slices through the picture from top right to lower left, dividing action from inertia and distance from proximity, while startling the observer into an encounter with energy. True to form, however, Degas resists the lure of the merely spectacular, bringing us firmly down to earth with his silhouette of the chinless ballet-master and the newspaper-reading housewife. In *Entrance of the Masked Dancers*, we are even more audaciously plunged into the drama, this time sharing the wings with two anxiously departing ballerinas who seem to sweep past us in a blur of colour. Contrasting shadow with blazing light, soft focus with distant detail, Degas might almost be demonstrating the sheer exhilaration of 'rendering movement and painting pretty clothes'.

Similar complexities of space and human orchestration were explored in a sequence of unusually panoramic canvases, such as *The Dancing Lesson*. Degas's practical motivation for choosing this format is uncertain, but it is possible that such scenes were intended as decorative panels in private houses, of a kind that Monet, Renoir, Caillebotte and others tackled at this time, or conceivably as studies for unachieved murals. In *The Dancing Lesson*, it is the spaciousness that first catches our eye, artfully heightened by the rhythmic pattern of figures across the breadth of the rectangle, like punctuation marks in a sentence or notes on a musical stave. Paradoxically, there is more space than substance, the sweep of the floor occupying much of the left-hand side and a blank, dreary wall the right-hand corner.

Nothing could better express the bleakness of the dancers' lot, the solitariness of their exertions and the drabness of their daily surroundings, with only the pale light from the window and the tints of a fan to relieve the gloom.

P lausible though such spaces become, we must never underestimate the artifice of Degas's creations nor his capacity, synthetically and almost wilfully, to manufacture new variations on older designs. By this date, several of the postures in *The Dancing Lesson* had been used a dozen times before, transferred by means of a squared-up drawing, such as *Dancer Adjusting her Tights*, or redrawn for the occasion. Similarly, compositions featuring the cluster of dancers on a bench and a distant line of their high-kicking colleagues had reappeared in various guises, some of which were to persist into the 1890s and beyond. Crucially, however, we know that Degas in mid-career still maintained regular, sometimes daily, contact with the world of the dance, revitalizing his repertoire and refreshing his sense of detail. Degas himself refers only fleetingly to such matters in his letters and notebooks, but the testimony of his contemporaries tells of performances visited and stars of the stage singled out for admiration, of social gatherings when dancers were present and posing sessions in the studio. Writing to another enthusiast for the dance, Albert Hecht, in an undated letter, Degas asked:

> Have you the power to get the Opéra to give me a pass for the day of the dance examination, which, so I have been told, is to be on Thursday? I have done so many of these

dance examinations without having seen them that I am a little ashamed of it.

A number of Degas's notes can be related to specific operas, ballets or the appearances of celebrities, and it is evident that, at certain periods, he went very regularly to performances. Certain close friends, like Reyer and Halévy, were directly involved in the music, libretti and details of particular productions, requiring Degas's presence and perhaps seeking his advice. More touchingly, Degas became personally concerned in the plight of certain dancers. In one case, he sought help for a former ballerina who was dying and, on another occasion, he wrote to Ludovic Halévy about an employee at the Opéra, urging him to petition the directors on her behalf:

> You must know what a dancer is like who wants you to put in a word for her. She comes back twice a day to know if one has seen, if one has written ... If you have the courage or the strength write a line to Vaucorbeil, to Mérante, not about her engagements which would be silly, but about her dancing and her past and her future.

By the late 1880s, Degas's attitudes to the subject matter of the Impressionist years had begun a process of profound change. Records of his attendances at the ballet, for example, indicate that he saw live performances less and less frequently and there is comparable evidence of a fading interest in the racetrack. For Degas, as for many of his former Impressionist colleagues, the documentary project of their younger days had lost much of its urgency, now overtaken by profounder challenges of both technique and pictorial purpose. Turning his back on many of

the themes that had brought him fame in earlier decades, such as the portraits of entertainers and street scenes, the laundresses and milliners of the first Impressionist displays, Degas also abandoned the minute description of his urban surroundings. Spaces became more indeterminate and individuals less sharply characterized as Degas moved in closer to the figure, broadened his handling of charcoal, pastel and paint, and concentrated on the visual drama of his models' gestures and bodily dispositions. Developing what the artist himself called 'an art of renunciation', Degas returned again and again to two principal subjects – the dancer and the bathing nude – in an extraordinarily sustained scrutiny of the female form.

this last phase of Degas's art is the least known, but arguably the most challenging of his long career. Continuing his working routines well into the twentieth century, though abandoning his studio some time before his death in 1917, Degas produced pastels and oil paintings of unprecedented intensity, charcoal drawings both tender and near-violent, and sculptures of the female body that are amongst the most radical of their age. Though the range of his subjects narrowed markedly, his sheer productivity was unabated and his obsession with the dance became more focused and determined. Now exploiting tracing as a means of returning to the same composition in picture after picture, Degas directed his energies at the fundamental properties of his human subjects: their mass and solidity, their bodily relationship to other figures in the depicted scene and the choreography of their poised, stretched and gesticulating limbs. No longer do we admire the ballerinas'

20

ribbons and their finely indicated jewelry, nor look for male intruders among the distant scenery. These dancers stand for themselves, for the common experience of strain and exhaustion, of surviving from day to day.

Red Ballet Skirts might be taken as the paradigmatic late Degas dance subject. By contrast with the echoing practice halls of the 1870s and the wide vistas of the 1880s, the fictive space now seems cramped, almost tormented in its dense graphism and hot colour. With effort, we can identify scenery behind the dancers, then deduce that they are waiting for their entrance on stage or for a performance to end. But these issues are obscure, perhaps irrelevant to the artist's palpable concerns. The real subject of this glorious work is the human frame in its frank expressiveness, an arched back telling of sustained exertion and heavy legs and arms of ballerinas no longer young. Bold charcoal lines – virtual slashes of blackness – define contours and articulate muscles, while waves of saturated colour flow across the entire scene. In *Red Ballet Skirts*, fiery oranges and scarlets fuse together in almost unbearable intensity, while in other traced variants of the scene a gentler climate of greens and yellows is explored, or a cool gamut of blues.

Such pronounced colour has a dual effect, both unifying the composition – Degas talked often of the importance of the ensemble – and heightening its emotional atmosphere. In *Dancers in Blue*, a group of figures is linked together by a single dominant hue and touches of other colours, such as the pinks on the dancers legs, only serve to emphasize this ascendancy. The relatively cold steel blues,

turquoises and aquamarines suggest a world of shadow and stability, contrasted with hints of brightly lit bustle in the distance. In such works we become aware of colour itself, not just as a decorative element but as a series of challenges to the painter and as a gamut of expressive possibilities. In *Group of Dancers*, it is the contrast between two complementary tints – a deep red-brown and a peppermint green – that establishes the harmony of the painting, each intensifying the other and defining space, energy and surface. But as always in Degas, colour is never merely an end in itself, here determining the pale, statuesque remoteness of the dancers and the opposing warmth of the distant room.

t he American collector, Louisine Havemeyer, asked Degas in his later years why he always painted ballet dancers, to be told: 'Because, Madame, it is all that is left of the combined movement of the Greeks.' Degas's meaning is not entirely clear, but it evidently marks a radical departure from his ambition as the documentary 'painter of dancers' in the Impressionist years. It was widely believed that formal dancing had reached a peak of simple elegance in classical civilization, involving not only music, costume and drama but the ritualized values of Greek society itself. Degas appears to have looked back wistfully in his old age to these values and to the arts that sustained them, integrating a sense of rhythmic, orchestrated movement into his groups of dancers and stressing their cohesion as visual forms. *Dancers* shows a cluster of ballerinas at close quarters, their arms and torsos locked together in vibrant patterns and their separate identities almost fused in a blaze of

colour. With *Dancers at the Barre*, this musical relationship between the pictorial elements is even more emphatic, while the resemblance to a shallow carved relief, of a kind that Degas and his contemporaries associated with ancient Greece, is palpable.

By the turn of the century, Degas had cut himself off almost completely from the theatres and dance halls of his earlier life, contriving his art from the models who continued to pose in his studio, from his prodigiously retentive memory and from pure invention – 'a painting requires a little mystery, some vagueness, some fantasy,' he told a friend. Still turning to the dance as the subject for the majority of his sculptures, his figure compositions in charcoal and pastel and his occasional excursions into oil paint, he allowed himself greater licence to repeat compositions and revise earlier works, obsessively returning to certain designs until he sometimes destroyed his own works of art. In Degas's late scenes of backstage life, the metamorphosis is stark and not without its paradoxes. Having chosen at the beginning of his professional career to document this most elusive of subjects, Degas had first fixed on its actuality, recording the doubtful antics of girls like the Cardinal sisters and the amorous attentions of their male consorts. In the pictures he made at the end of his life, much of this particularity has evaporated. *Two Dancers Resting* of c. 1910 is among the last works the artist accomplished, returning nostalgically and almost desperately to the theme of tired ballerinas resting on a bench. Though distantly rooted in the facts of the dance, this pastel has become vaporous and near-incoherent, as fantastical as anything seen or depicted by Degas on the stage itself.

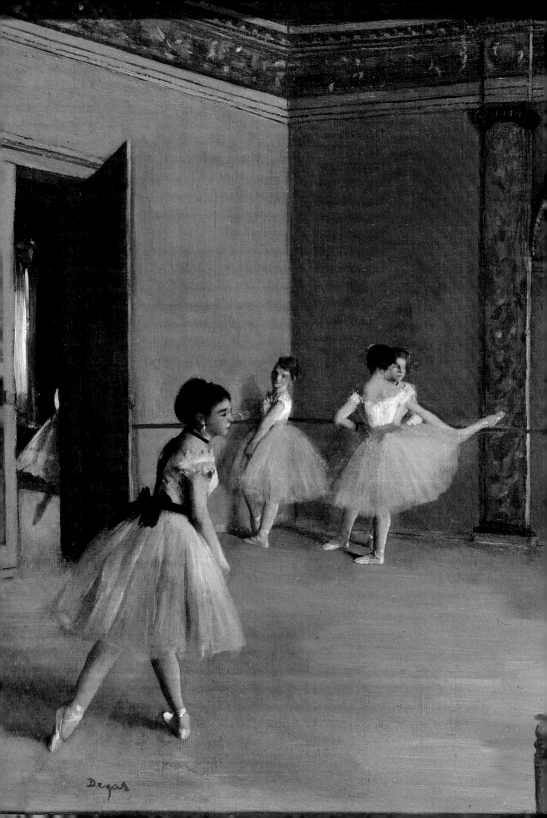

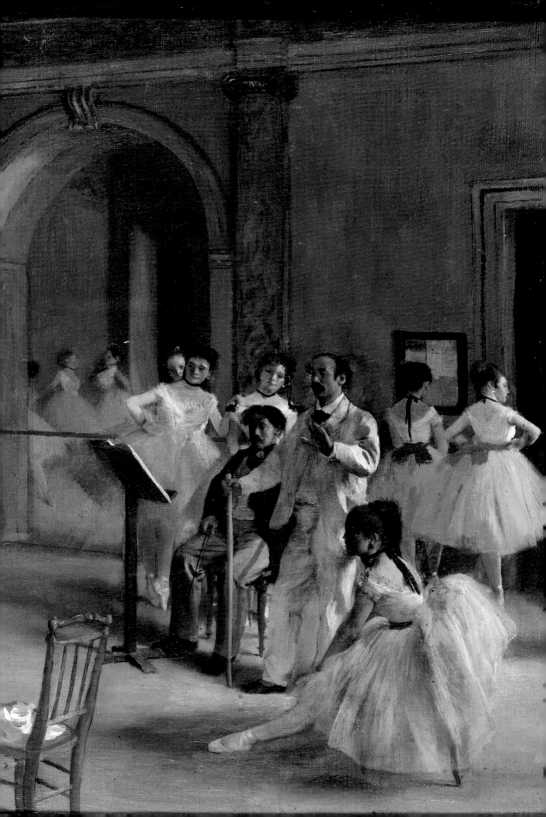

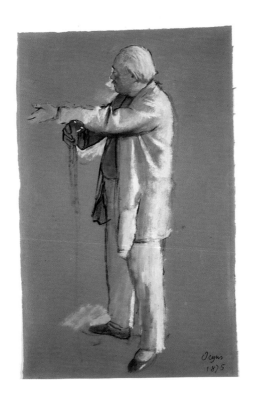

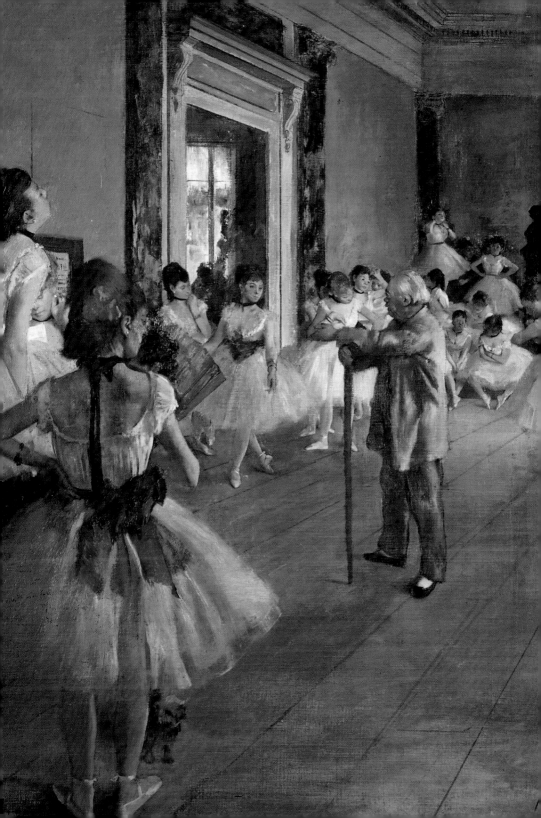

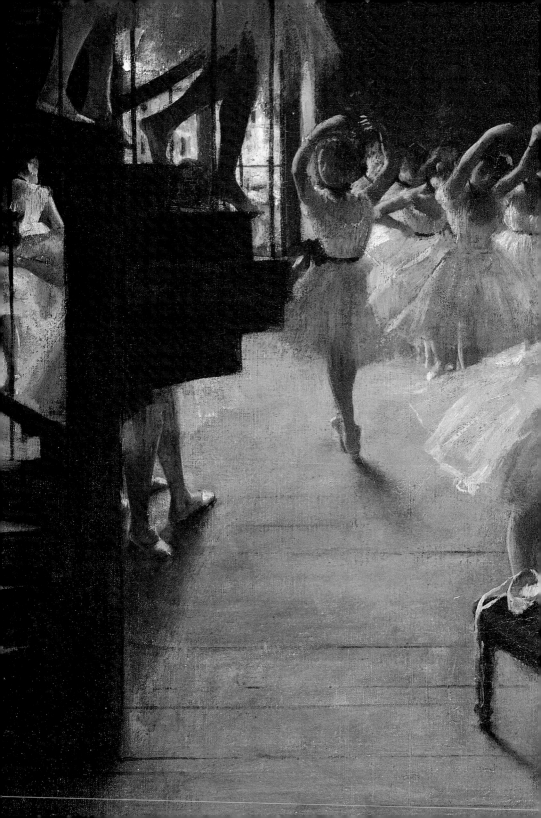

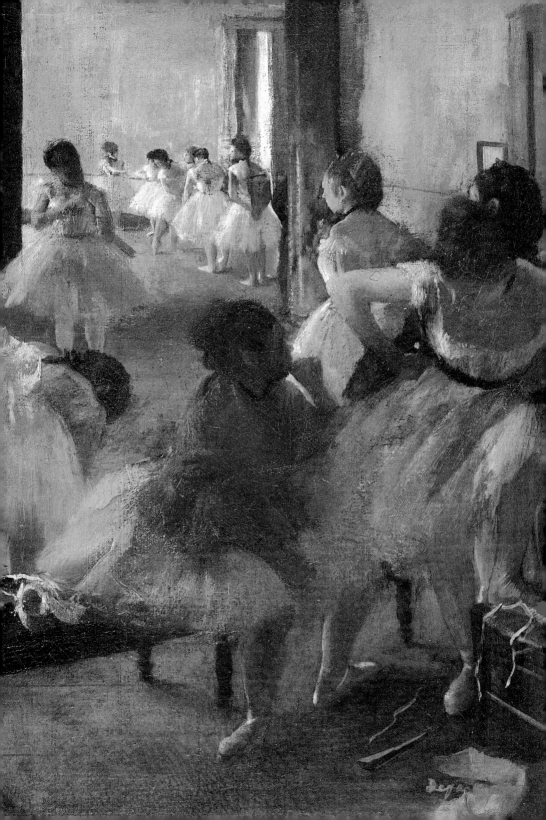

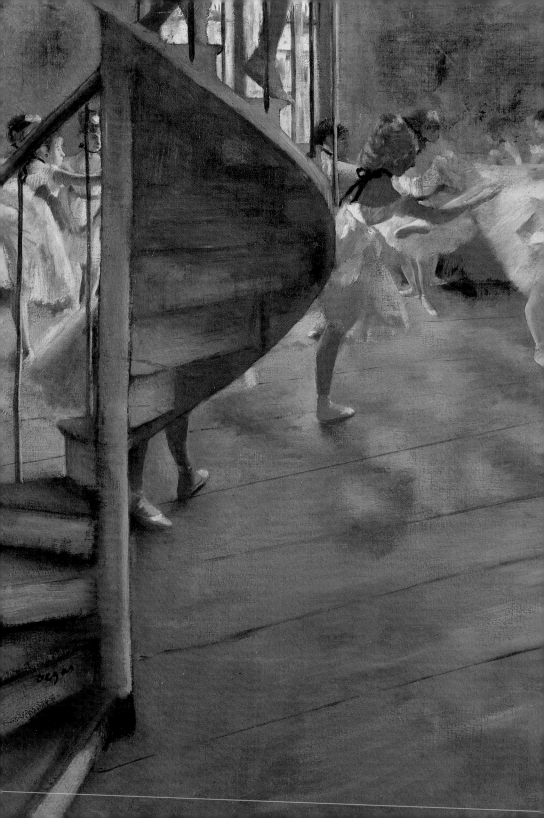

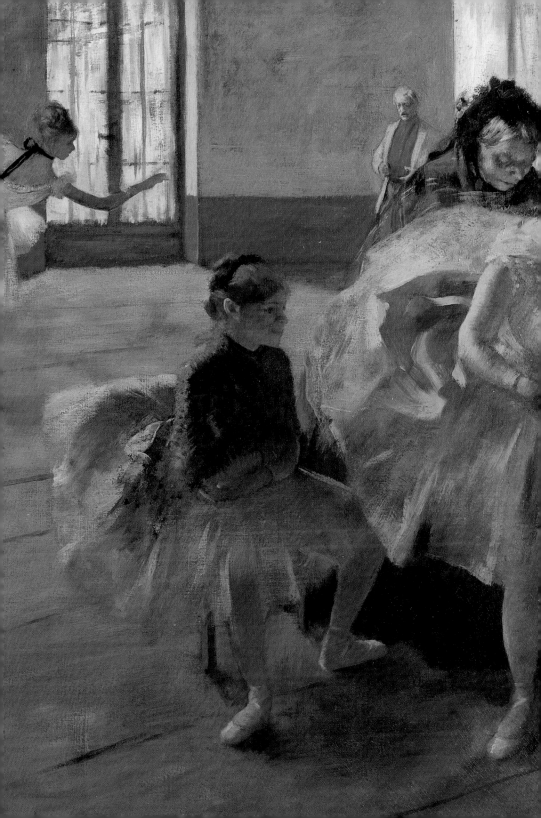

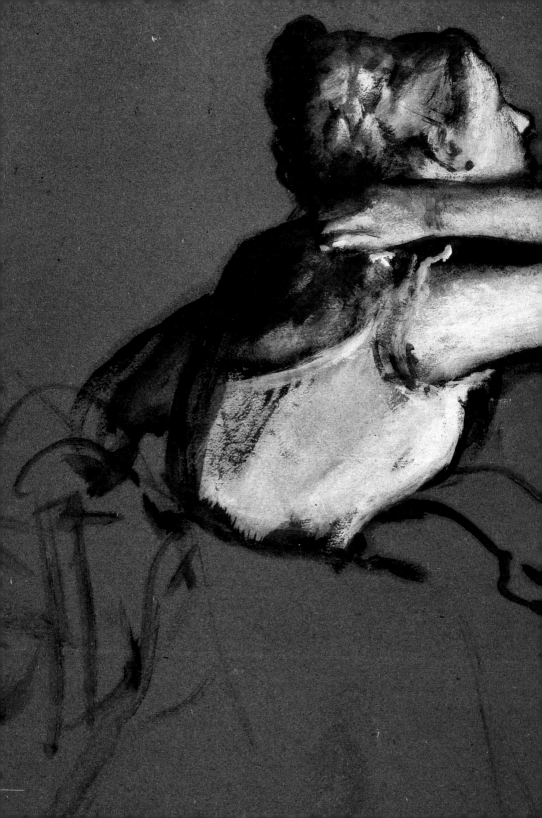

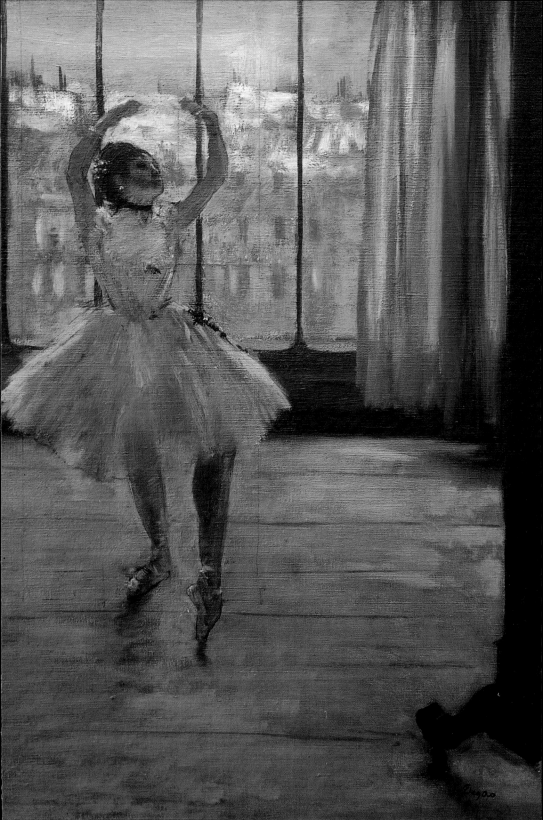

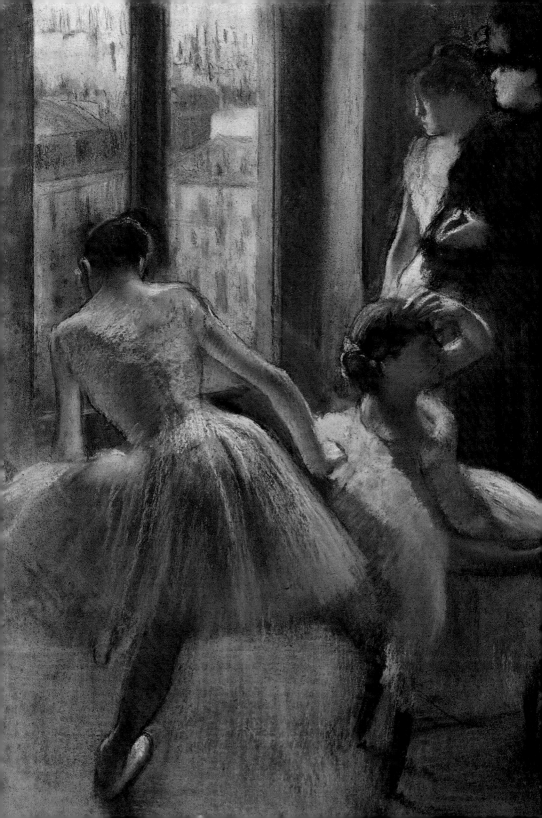

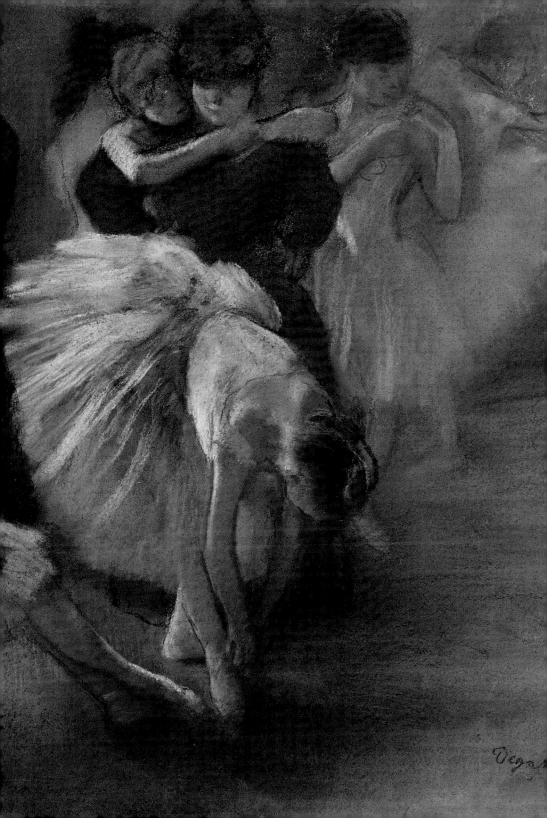

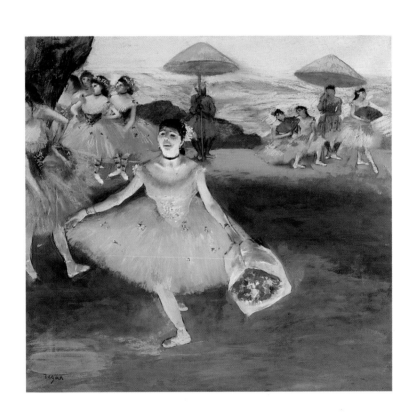

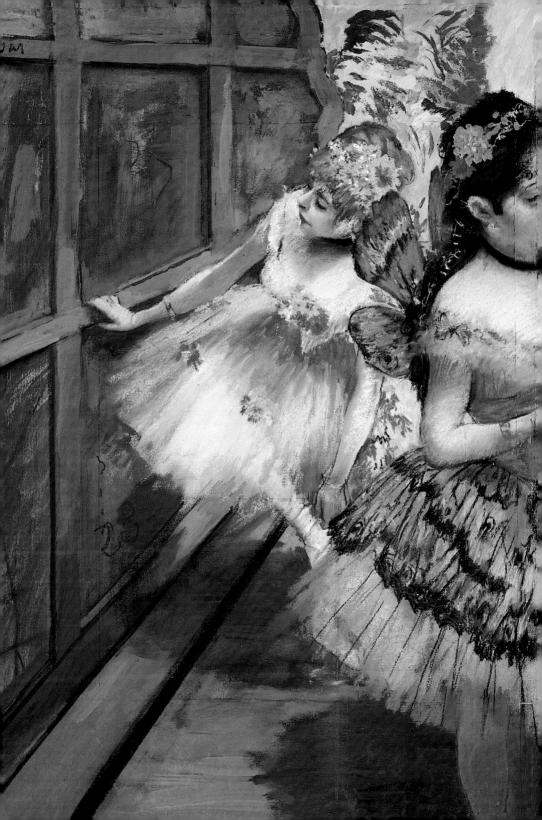

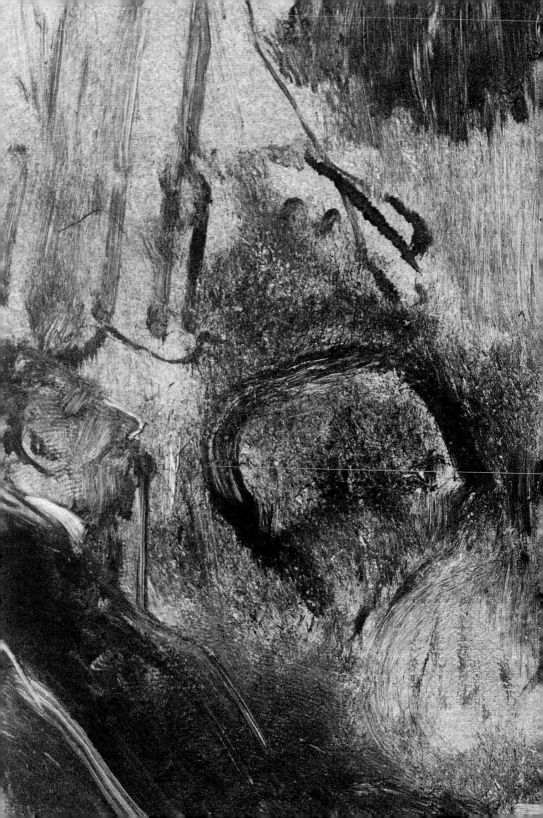

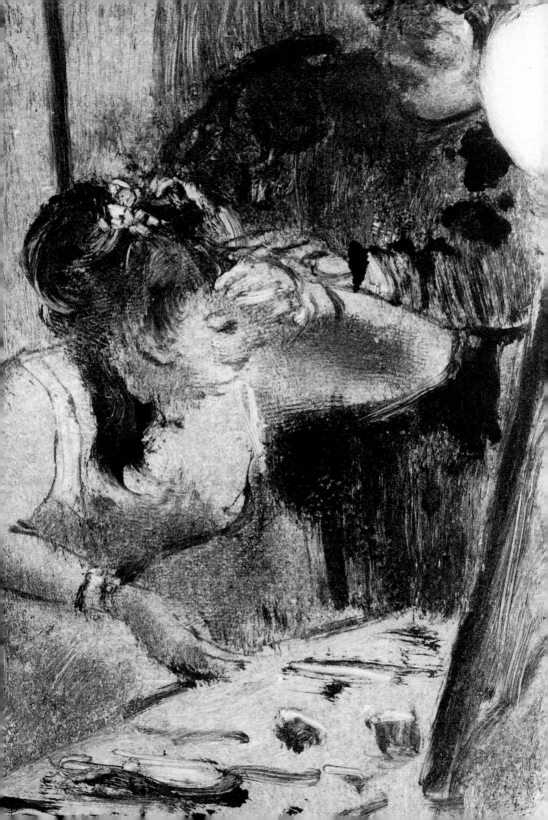

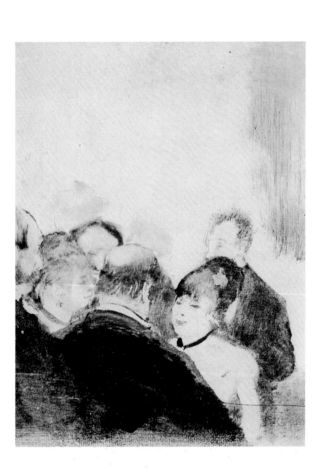

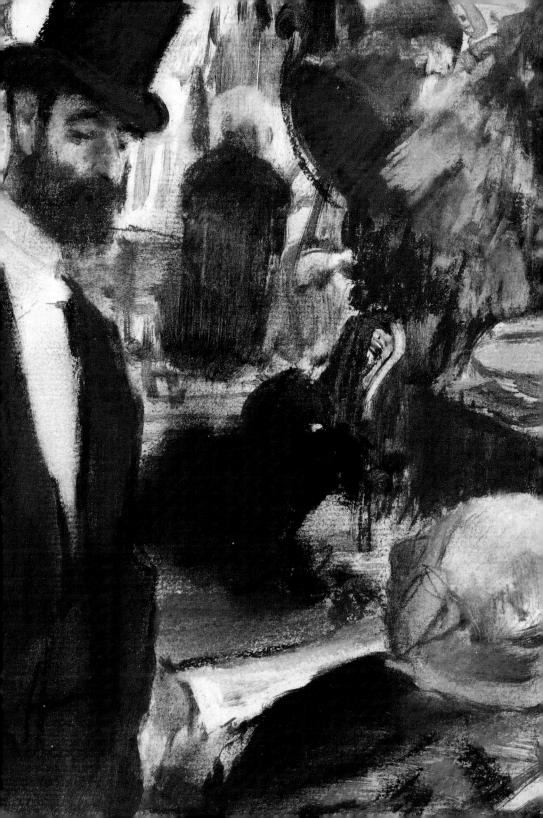

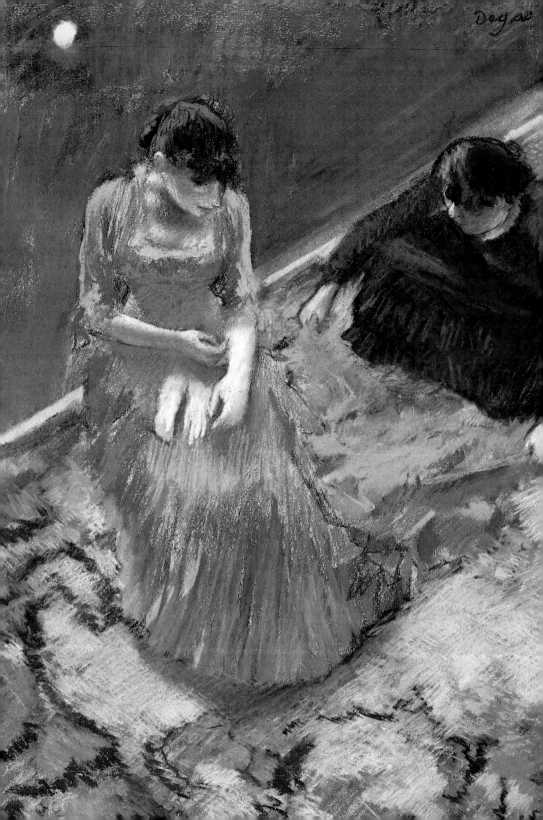

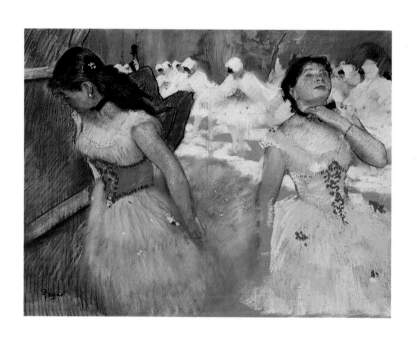

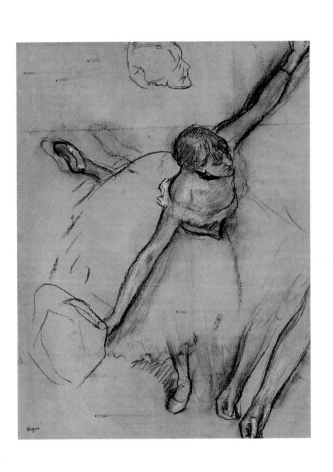

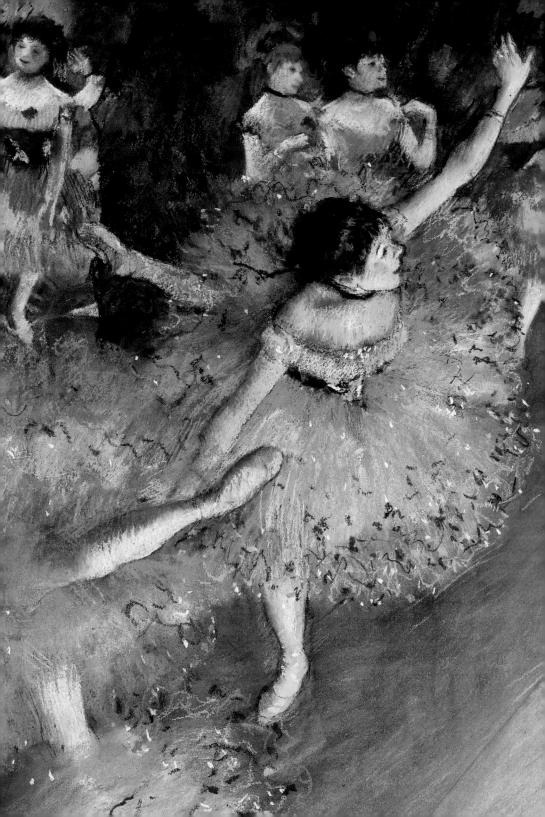

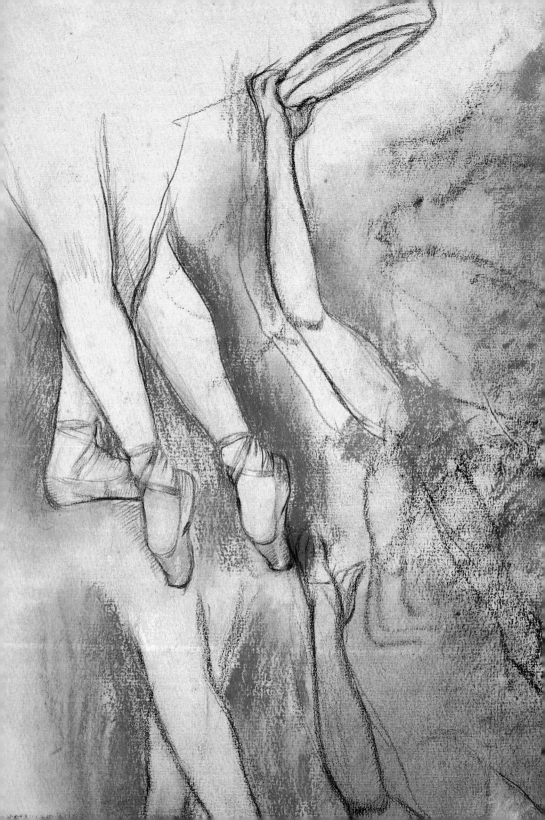

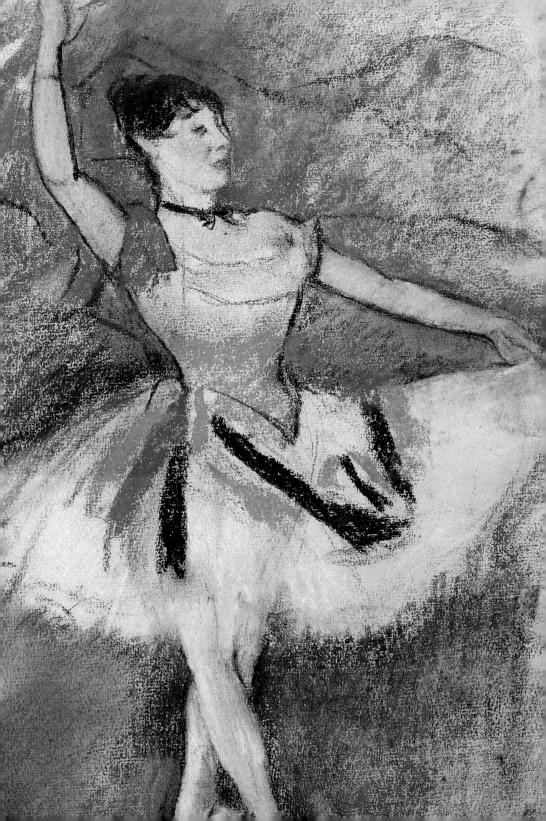

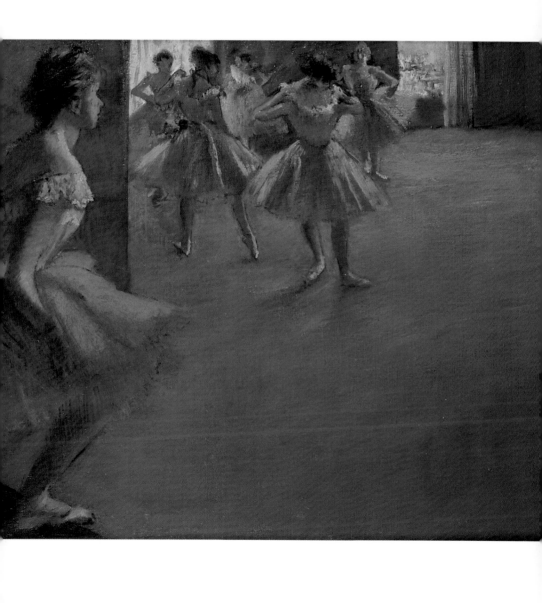

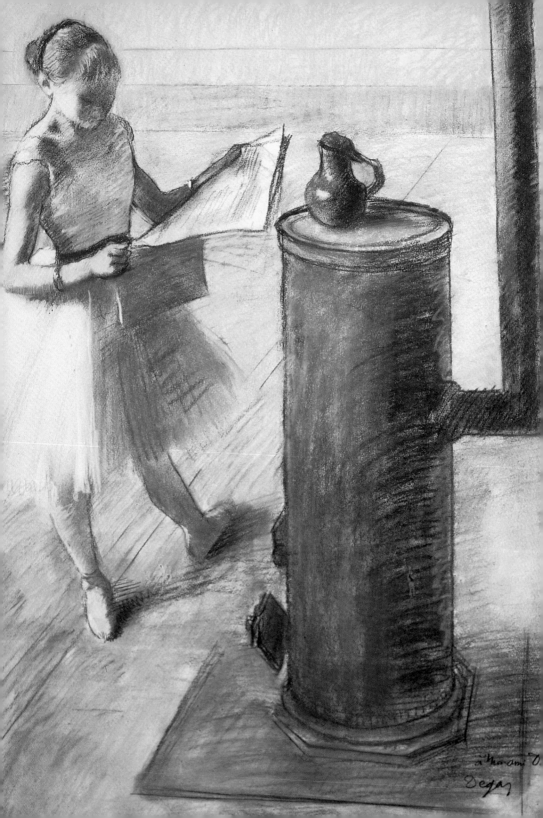

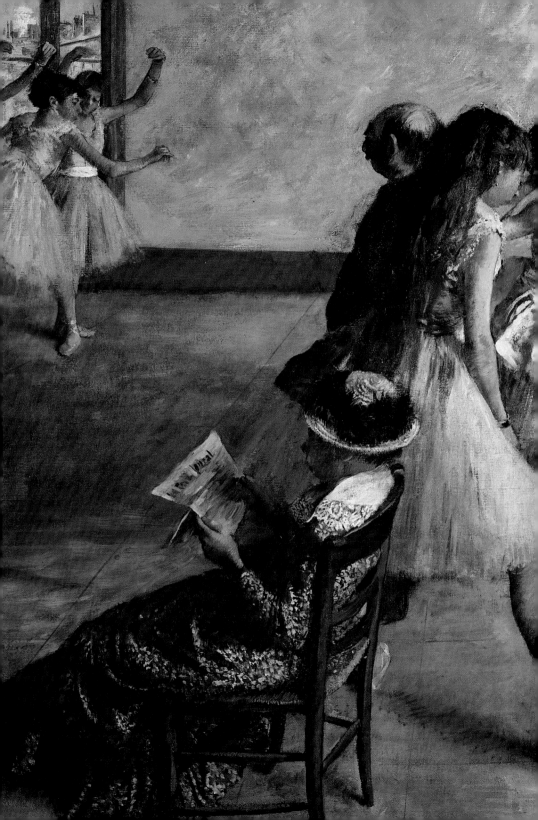

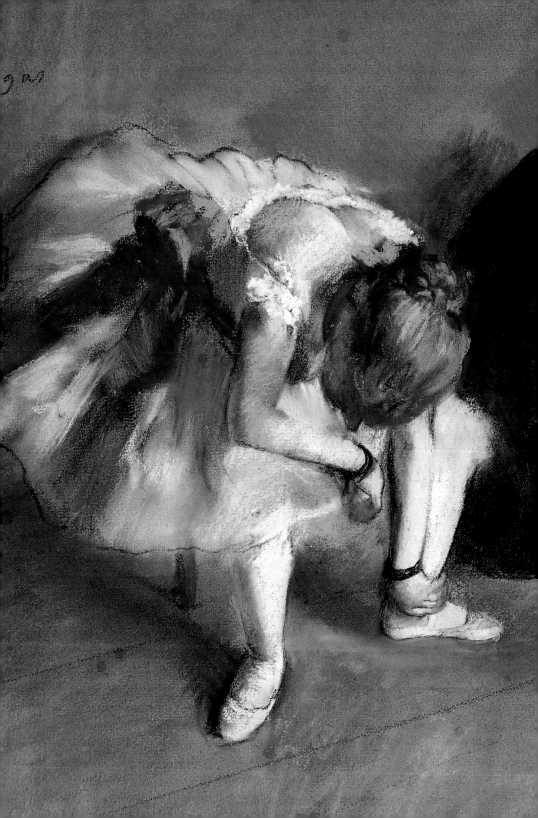

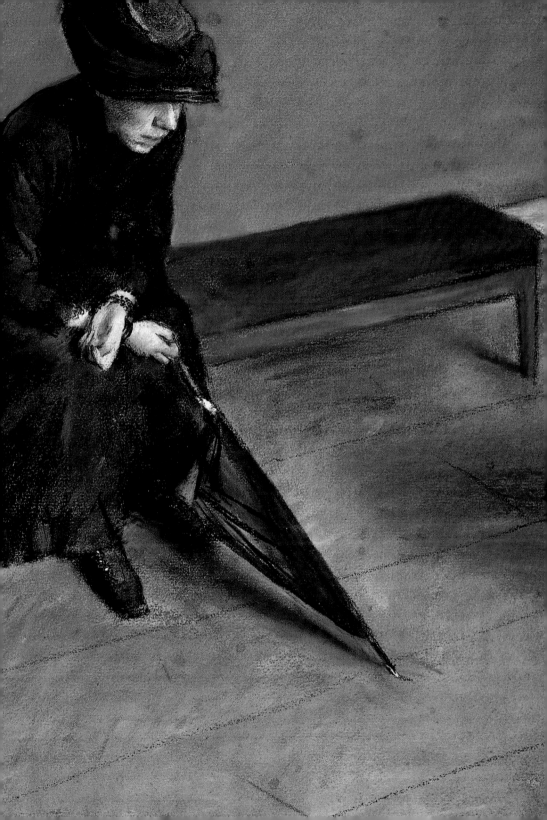

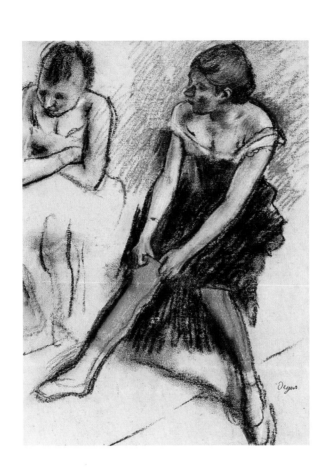

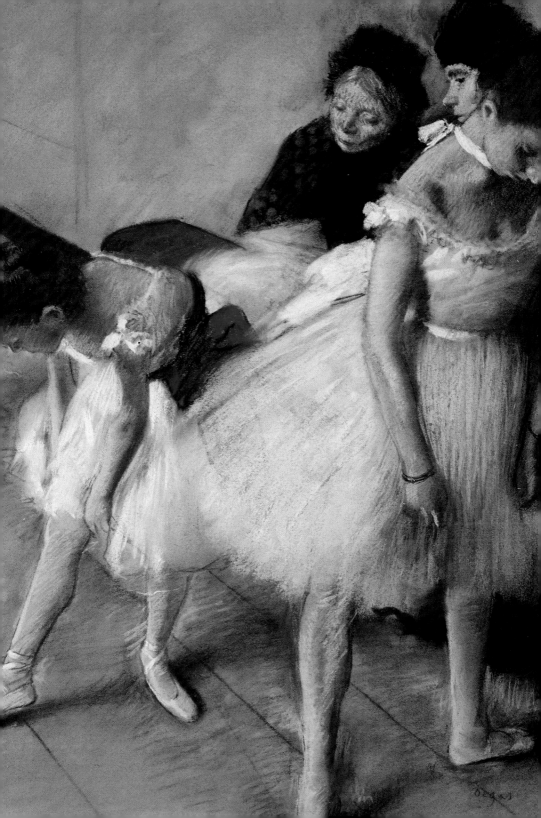

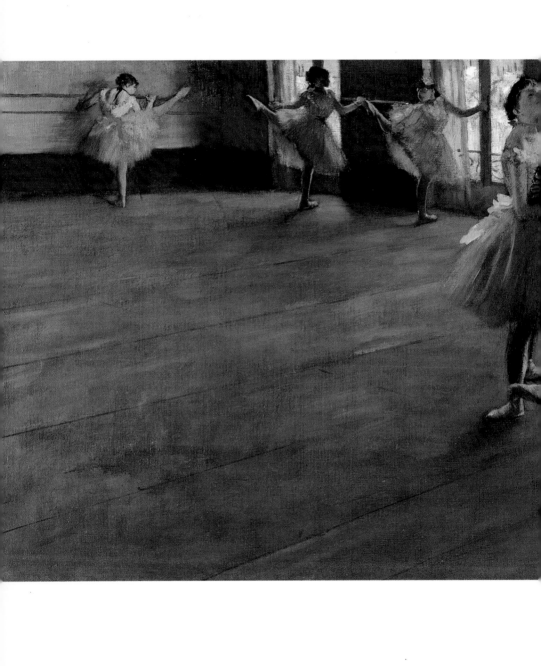

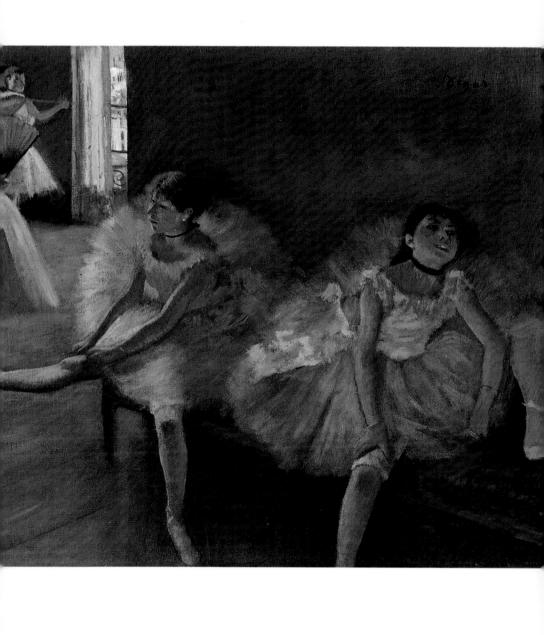

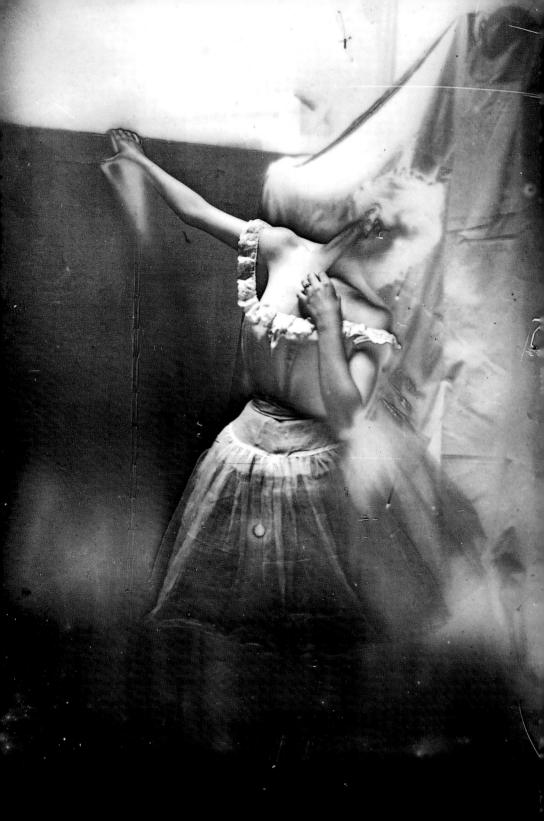

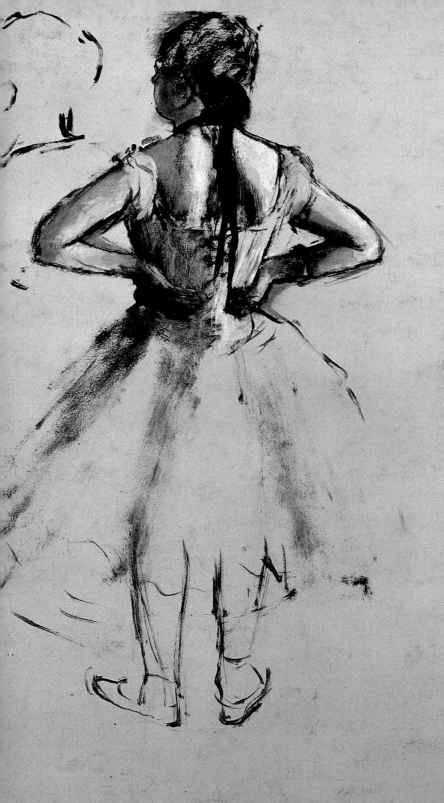

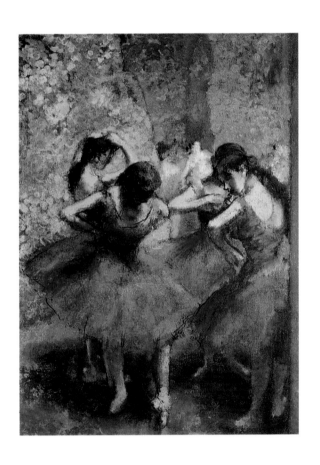

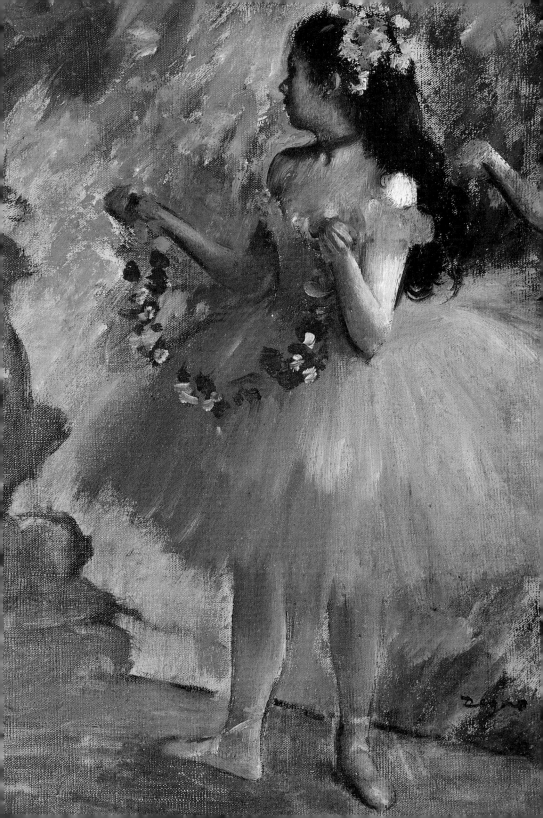

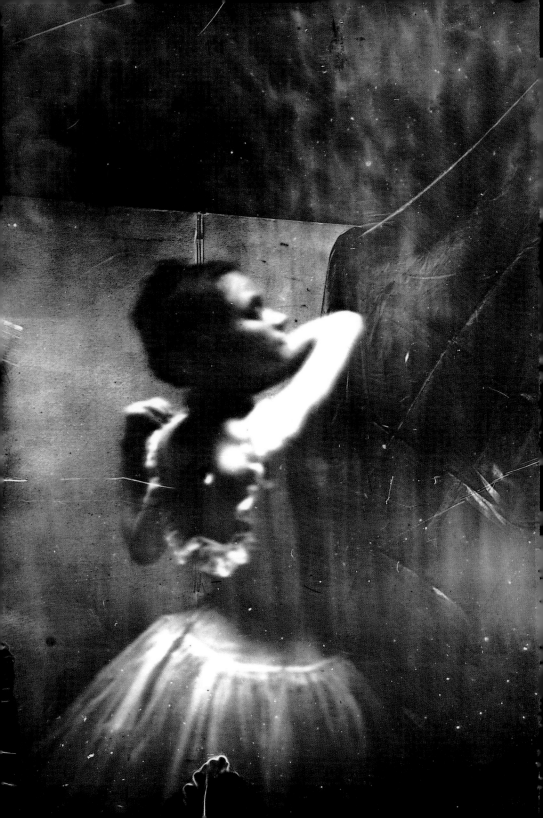

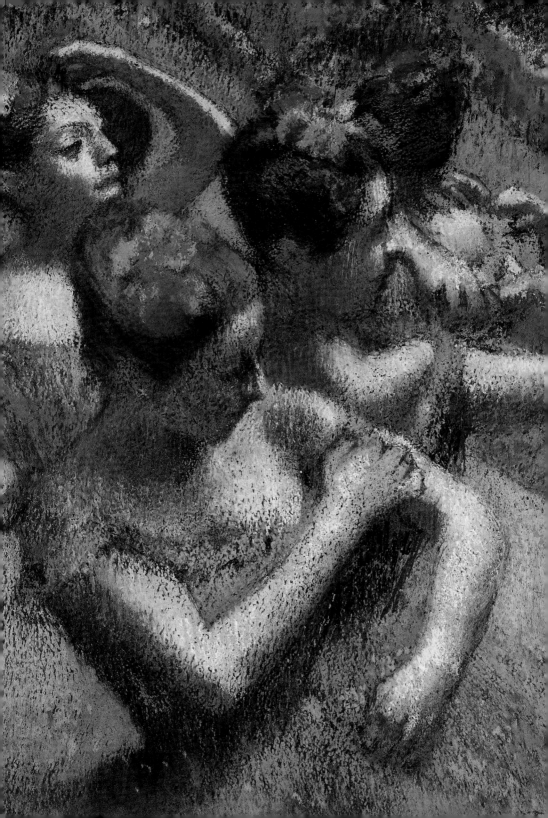

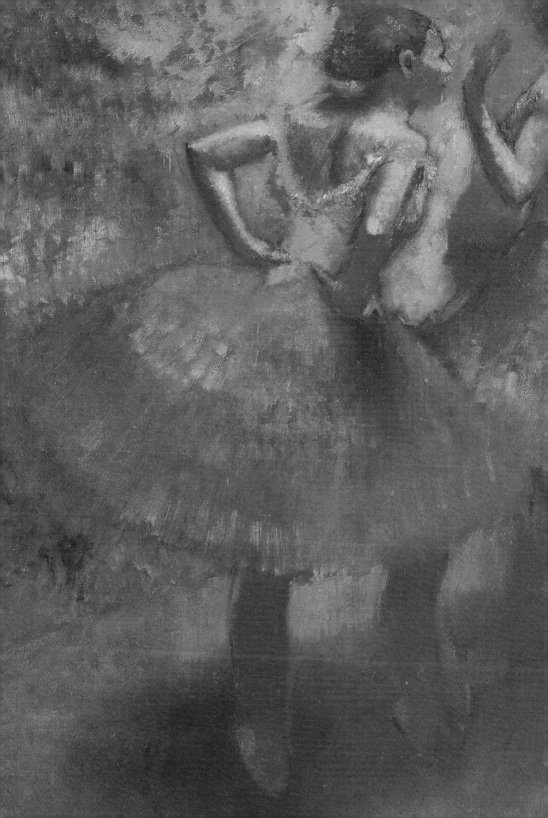

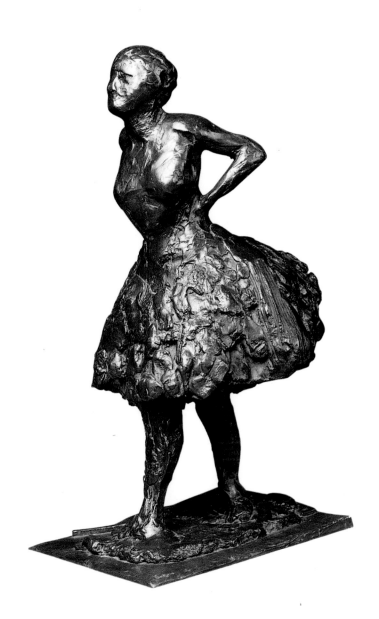

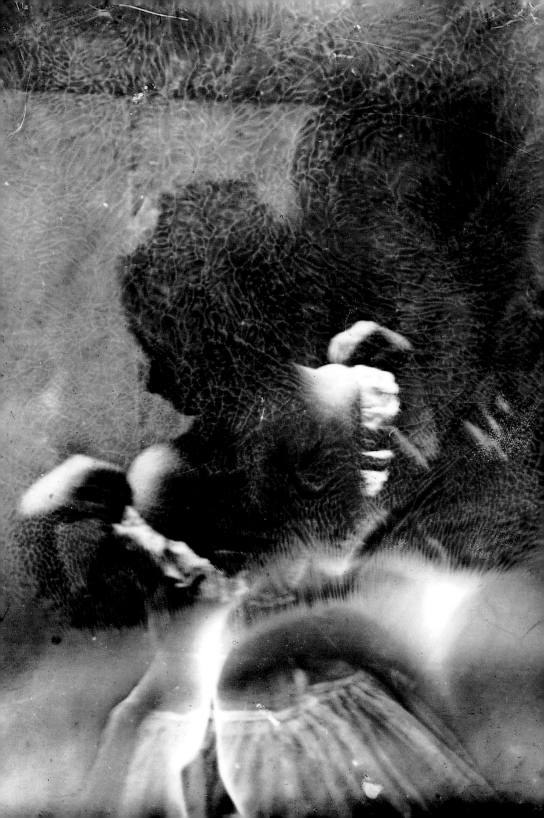

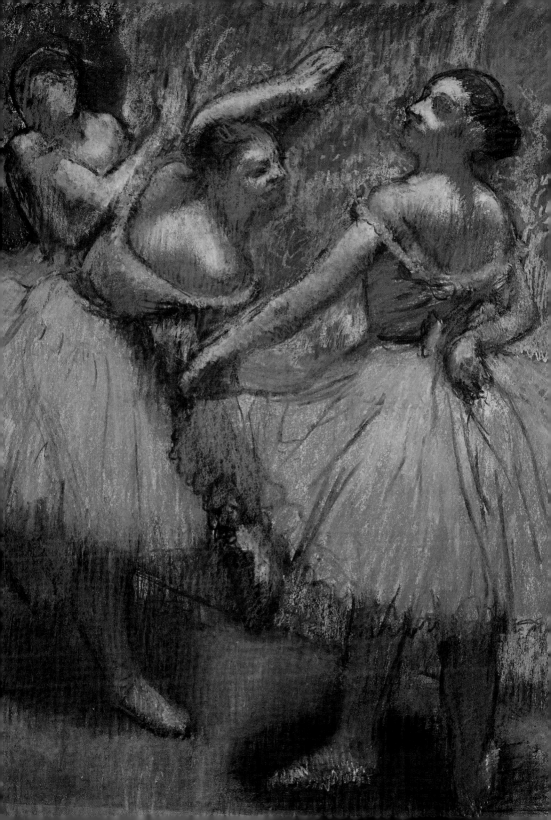

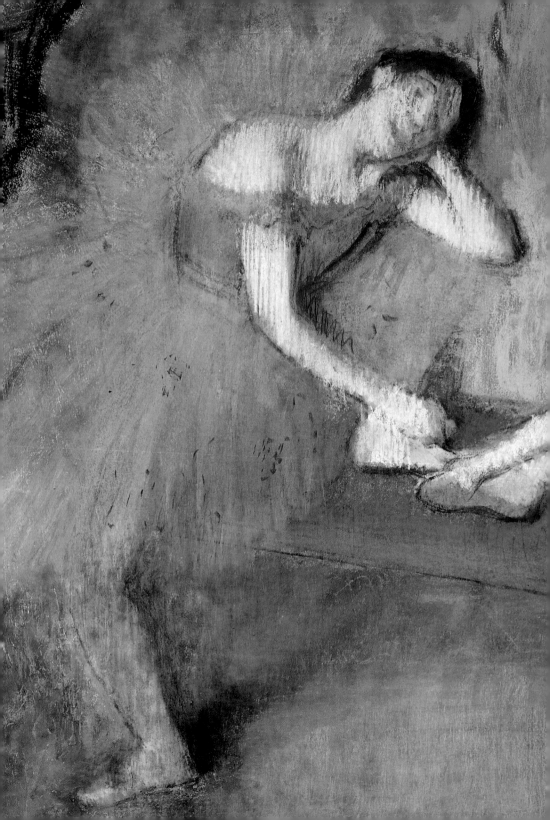

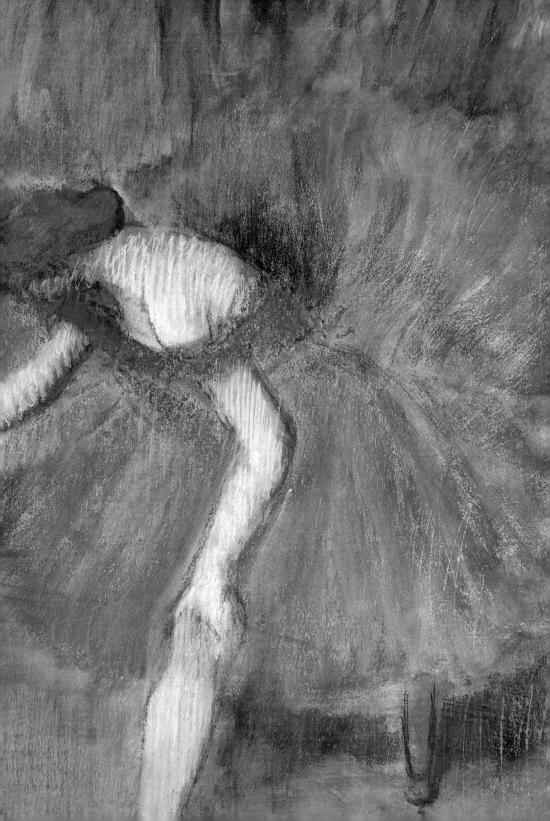

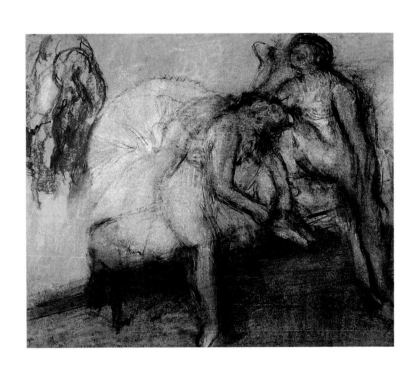

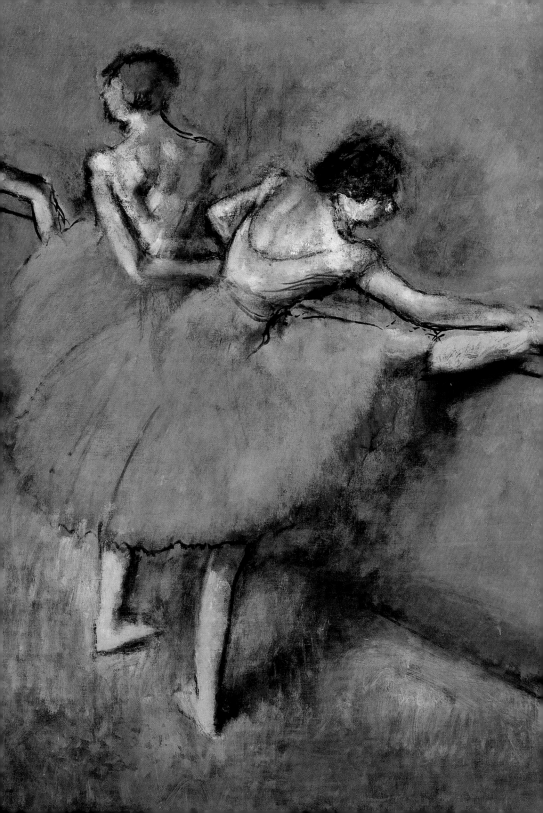

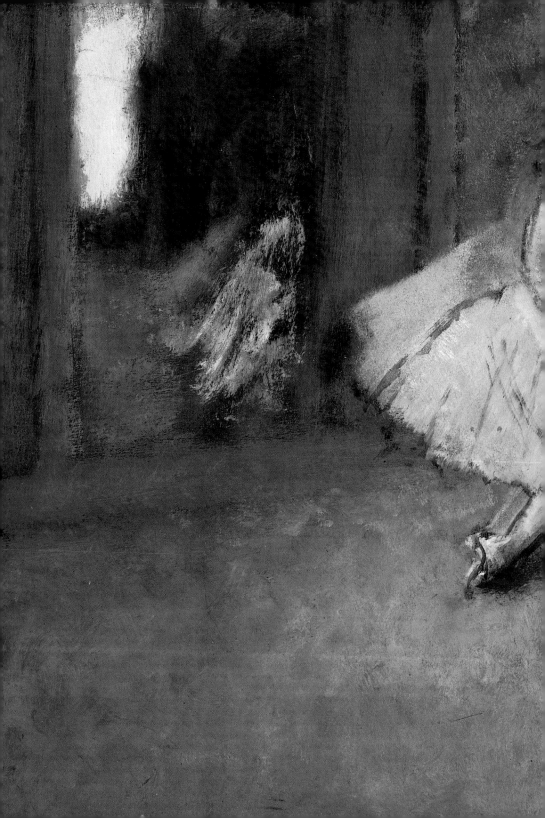

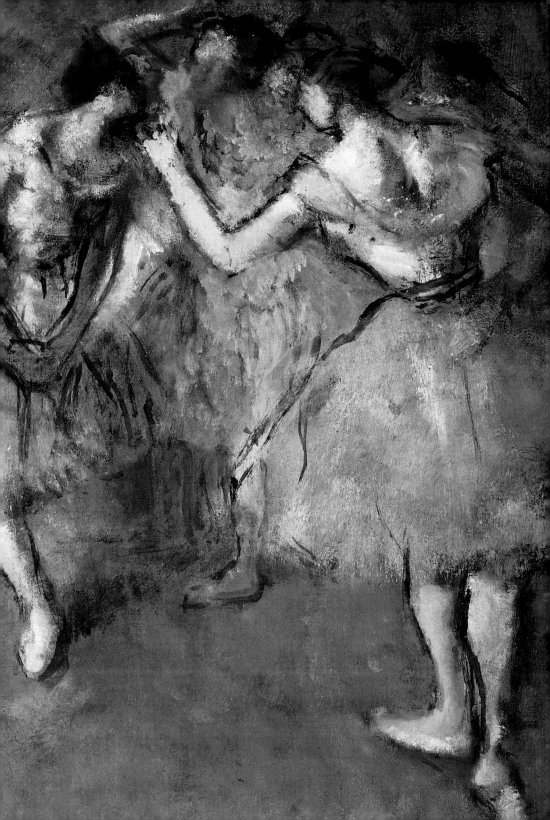

Degas Backstage

Dance Class at the Opéra, 1872. Musée d'Orsay, Paris. © photo R.M.N. This tiny canvas was one of Degas's very first dance rehearsal scenes but has remained among the most popular of his early works. Perhaps because he was still uncertain of his audience, Degas opted for a serene, light-filled setting, though glimpses through doorways and in a mirror suggest complexities to come.

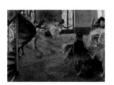

Jules Perrot, 1875. Philadelphia Museum of Art. The Henry P. McIlhenny Collection in Memory of Frances P. McIlhenny. Perrot was an international celebrity in his earlier years, first as a dancer at the Paris Opéra, then as a choreographer. The Dance Class, begun 1873, completed 1875–76. Musée d'Orsay, Paris. © photo R.M.N. Here Degas shows Perrot as he approached retirement, rehearsing dancers in the kind of crowded practice room he had known as a young star.

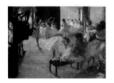

The Dance Class, 1873. In the collection of The Corcoran Gallery of Art, Washington, D.C., William A. Clark Collection. Though painted early in his career, The Dance Class offers a virtual catalogue of the ballet subjects that were to preoccupy Degas for the next three decades: the sequence of dancers' legs on the spiral staircase, vividly suggesting movement; the clusters of ballerinas, resting or echoing each other's poses; and the group of tired girls around a low bench.

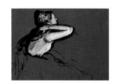

The Rehearsal, 1874. Glasgow Museums: The Burrell Collection. © Glasgow Museums. Seemingly chaotic, Degas's rehearsal scenes are ingeniously designed to suggest both energetic movement and the boredom of the waiting dancers. Here a rising curve carries us up through the spiral staircase and into the distant group of ballerinas, dropping suddenly to the static figures cut off by the right-hand side of the picture frame.

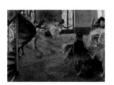

Seated Dancer in Profile, 1873. Musée du Louvre (Orsay), Paris. © photo R.M.N. One of several studies made for a group of paintings of ballet rehearsals, this powerful brush drawing reminds us of Degas's attention to human detail. Here a dancer scratches her neck and relaxes her tired body, perfectly captured by the artist in a few swift strokes.

Dancer Posing for a Photograph, 1875. Pushkin Fine Art Museum, Moscow. © photo A.K.G., Paris. Reminding us of Degas's lifelong familiarity with photographers and the conventions of their craft, this picture shows a ballerina transposed from the rehearsal room to a roof-level photographic studio, where she strikes a pose against a view of Parisian buildings and appears to check her appearance in a large mirror.

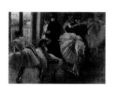

The Dance Foyer, *c.* 1880. Glasgow Museums: The Burrell Collection. © Glasgow Museums. Most of Degas's pastels of backstage life are arranged to discourage a straightforward narrative, but here it is difficult not to link the participants in some way. The dancer and her chaperone at the window look uncertainly at the grim outside world, the couple beside them cling to each other for reassurance, while other figures seem to progress towards confident display.

Dancer with a Bouquet Bowing, *c.* 1877. Musée d'Orsay, Paris. © photo R.M.N./Schorman. For once, Degas shows us not only a performance of a ballet but a view of a specific production, probably Massenet's *Le Roi de Lahore*.
Dancers in the Wings, *c.* 1880. Norton Simon Art Foundation, Pasadena, CA. More characteristic of the artist is this view, where gorgeously apparelled dancers are poised against a dreary scenery flat, encapsulating their paradoxical world.

Intimité, 1876–77. Statens Museum for Kunst, Copenhagen. © photo Hans Petersen. Using all the resources of the monotype medium, Degas has brushed, smeared and wiped the black ink across his copper plate, then rapidly printed the result. Here we see a dancer or actress, the surrounding veils of tone suggesting her lamp-lit dressing-room and the figures in the shadow hinting at more personal dramas.

The Cardinal Sisters Talking to their Admirers, 1876–77. Musée du Louvre (Orsay), Paris. © photo R.M.N./J.G. Berizzi. Degas used his newly perfected technique of monotype to illustrate the flirtatious world of Halévy's stories.
Ludovic Halévy Finds Mme Cardinal in the Dressing Room, 1876–77. Staatsgalerie Stuttgart. © photo Graphische Sammlung. Mme Cardinal chats with her visitor, here standing in for the predatory males who frequented the Opéra.

Before the Curtain, *c.* 1885. Wadsworth Atheneum, Hartford, CT. Almost unprecedented in Degas's œuvre, this bird's-eye view of a singer or actress as she prepares to confront her audience is both visually and psychologically tense.
Entrance of the Masked Dancers, *c.* 1881. Sterling and Francine Clark Art Institute, Williamstown, Massachusetts. © photo 1992 Clark Art Institute. Degas contrasts the brilliant colours of the stage with the half-light of the wings.

Dancer with a Bouquet, *c.* 1879–80. Musée du Louvre (Orsay), Paris. © photo R.M.N./J.G. Berizzi. Few subjects interested Degas more at this period than a moment of disequilibrium, when a dancer balanced by sheer willpower.
Green Dancer, *c.* 1880. Thyssen-Bornemisza Collection, Lugano. © photo A.K.G., Paris. In the finished pastel, the void beneath the dancer accentuates her precariousness and only the blaze of the footlights seems to prevent her toppling.

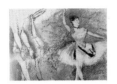

Spanish Dancer and Studies of Legs, c. 1882. Musée du Louvre, Paris. © photo R.M.N./Schorman. In preparation for his pastels and oil paintings of the ballet, Degas made vigorous studies of dancers posed in his studio, paying attention to their posture and the details of their costumes. Rather unusually, he has developed this sheet of studies and added his signature, as if proud of its vitality.

Dancers Climbing the Stairs, c. 1883–86. Musée d'Orsay, Paris. © photo R.M.N. Rushing to rehearsal or loitering in backstage corridors, Degas's flimsily clad dancers are often contrasted with the drabness of their working environment. In reality, their practice costumes were very plain, but the artist often added ribbons, coloured sashes and jewelry to enliven the scene.

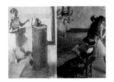

Dancer Resting, c. 1879–80. Private Collection. © photo A.K.G., Paris. The wit of Degas's ballet scenes, where an elegant dancer is edged out of the composition by an ugly stove or suddenly seen in all her awkwardness, is often underestimated. **The Dance Class**, 1881. Philadelphia Museum of Art. Purchased for the W.P. Wilstach Collection. Rehearsal rooms are frequently enlivened by figures in street clothes, the dark dress of a chaperone here contrasting with the white tutus.

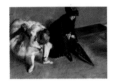

Waiting, c. 1880–82. Jointly owned by the Norton Simon Art Foundation, Pasadena, CA, and The J. Paul Getty Museum, Malibu, CA. Much admired in Degas's own day, this superbly economical image sums up the aspirations towards glamour and the daily routine, the flimsy artifice and the grim reality of backstage life for a young ballerina.

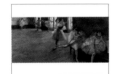

Dancer with Red Stockings, c. 1884. The Hyde Collection, Glens Falls, New York. Drawing and colour had always had a complex dialogue in Degas's art, the bright tints of pastel often answering and invigorating the sobriety of a study. **Dancers at their Toilette (The Dance Examination)**, c. 1880. Denver Art Museum, Anonymous gift. In his pastels of the 1880s, Degas resolved the demands of his most analytical draughtsmanship with unprecedented richness of colour and texture.

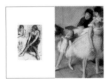

The Dancing Lesson, c. 1880. Sterling and Francine Clark Art Institute, Williamstown, Massachusetts. © photo Clark Art Institute. One of a series of horizontal canvases, *The Dancing Lesson* sets open space against a crowded bench, distant dancers against two cropped by the frame, and figures in effortless movement against those resting or adjusting their costumes.

Dancer from the Corps de Ballet, c. 1896. © photo Bibliothèque Nationale de France, Paris. Degas was fascinated by the forms and expressive capacities of the female body, even making photographs in the 1890s to capture poses for later use. **Standing Dancer Seen from Behind**, c. 1873. Musée du Louvre (Orsay), Paris. © photo R.M.N. Over twenty years earlier, his rapidly moving brush had performed a similar function, recording light on muscles and tautly held limbs.

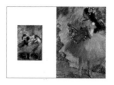

Dancers in Blue, c. 1893. Musée d'Orsay, Paris. © photo R.M.N. In later years, Degas abandoned fine detail and anecdotal surroundings in favour of intense colour and massively stated figures.

Dancer in Pink, c. 1880. Coll. Chauncey McCormick, Chicago. Photograph © 1996, The Art Institute of Chicago. All Rights Reserved. By contrast, this small picture from the Impressionist phase seems particularized.

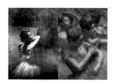

Dancer from the Corps de Ballet, c. 1896. © photo Bibliothèque Nationale de France, Paris. Though the technical quality of Degas's photographs could be poor, the pronounced arrangement of tones provided a vivid guide for his paintings.

Dancers, c. 1899. Private Collection. Photo Archives Durand-Ruel, Paris. *Dancers* and several related works have the closest affinity with his photographs, in their poses and effects of focus, light and texture.

Two Dancers in Green Skirts, 1894–99. Collection of Mr and Mrs Herbert Klapper, New York. Certain postures of dancers at rest seem to have obsessed Degas, reappearing in drawings, pastels, oils and sculptures.

Dressed Dancer at Rest, Hands on her Hips, c. 1895. Musée d'Orsay, Paris. © photo R.M.N. Rather than using models for his pictures, Degas sometimes worked directly from his own sculptures.

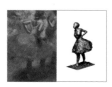

Dancer from the Corps de Ballet, c. 1896. © photo Bibliothèque Nationale de France, Paris. In his late photographs and pastels, Degas tended to move closer to his subjects, concentrating on a shoulder, a hand or the silhouette of a face.

Red Ballet Skirts, c. 1897–1901. Glasgow Museums: The Burrell Collection. © Glasgow Museums. This composition clearly fascinated Degas for several years, resulting in pastel variants in yellow, blue and green as well as bright red.

Two Dancers Resting, c. 1898. Paris, Musée d'Orsay. © photo R.M.N./ Schorman. In his choice of poses, the elderly Degas seemed determined to stress the angular and unbeautiful aspect of the dancers' bodies. Colour, also, dominates their individuality, surrounding them with melancholy or shadowy uncertainty.

Two Dancers Resting, c. 1910. Paris, Musée d'Orsay. © photo R.M.N. At the end of his working life, Degas's fixation with certain colours and expressive forms almost obliterated the identity of his subject.

Dancers at the Barre, c. 1900. © The Phillips Collection, Washington, D.C. In his last rehearsal scenes, line and colour can come together with unprecedented force, in a way that seems to prefigure the achievements of Matisse and Picasso.

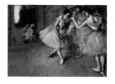

Group of Dancers, c. 1900–5. National Gallery of Scotland, Edinburgh. Some of Degas's backstage subjects reappeared at several points in his career, slightly modified or transposed into a different medium. This cluster of dancers beside a mirror or doorway had first been defined in a pastel twenty years earlier, then returned as an oil in the 1890s, before resurfacing in the early twentieth century.